ENKIDU

Seyfeddin E Erisen

Copyright ©Seyfeddin E Erisen, 2017

ISBN-13: 978-1548425937

ISBN-10: 1548425931

There was a time when the story of Gilgamesh and Enkidu was well-known, first, being told and retold a thousand times, from one generation to the next, then written in clay by scribes, and later, on parchment. The best-known version recounts how, at the time when the first cities were developing, in a place near the Euphrates River, called Uruk, the inhabitants complained to the gods that their mighty king Gilgamesh was too harsh. To resolve this, the goddess of creation, Aruru, took clay and water and created a wild man, Enkidu. "Go, and rid Gilgamesh of his pride and arrogance," said the goddess as she instilled life into Enkidu.

At first, Enkidu lived free in the wilderness, raised by animals, and ignorant of human society. However, Gilgamesh heard about Enkidu, and sent Shamhat, the sacred temple-prostitute, to seduce and teach him about humans and the 'civilised' human way of life. She encouraged him to come to the city.

When Enkidu approached, Gilgamesh challenged him to a wrestling match. Both were of similar strength, but Enkidu embodied the natural world, while Gilgamesh represented his antithesis, being a cultured, urban-bred worrisome king. Gilgamesh won, but the men became close friends, and Gilgamesh softened in his attitudes. One day, the goddess decided it was time for Enkidu to return to the skies. His friend's death inspired Gilgamesh to search for the key to immortality.

As the ancient Sumerian culture was submerged by others, the veil of time began to hide the Gilgamesh and Enkidu stories, and few of Earth's inhabitants knew of them. No longer did the epic tales of ancient heroes resonate with the worldly concerns of the more 'modern' people. Time followed its course.

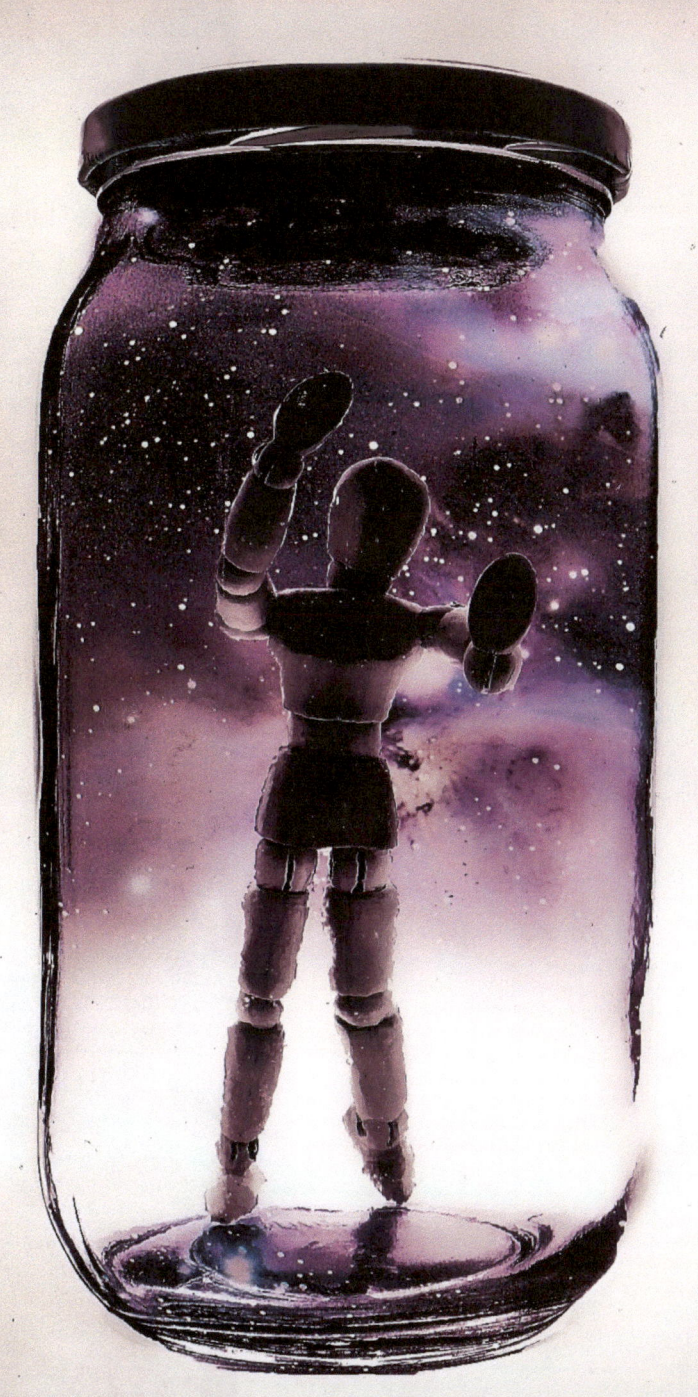

Is time a river? Maybe time is a mere illusion, an artificial sense of sequence where only chaos and unpredictability are the reality; or maybe, just maybe, time is circular, and then... Completing the circle he had begun, Enkidu's spirit is approaching Earth again. In the distance, he observes Gaia and her human load. His eyes are wide open, capturing all the nuances of the path that life had taken on this beautiful blue dot. Do they need his intervention? Are they improving as beings in the way he had hoped? If not, and if the greed, violence and selfishness that seemed spread through the human species had prevailed, then he would intervene

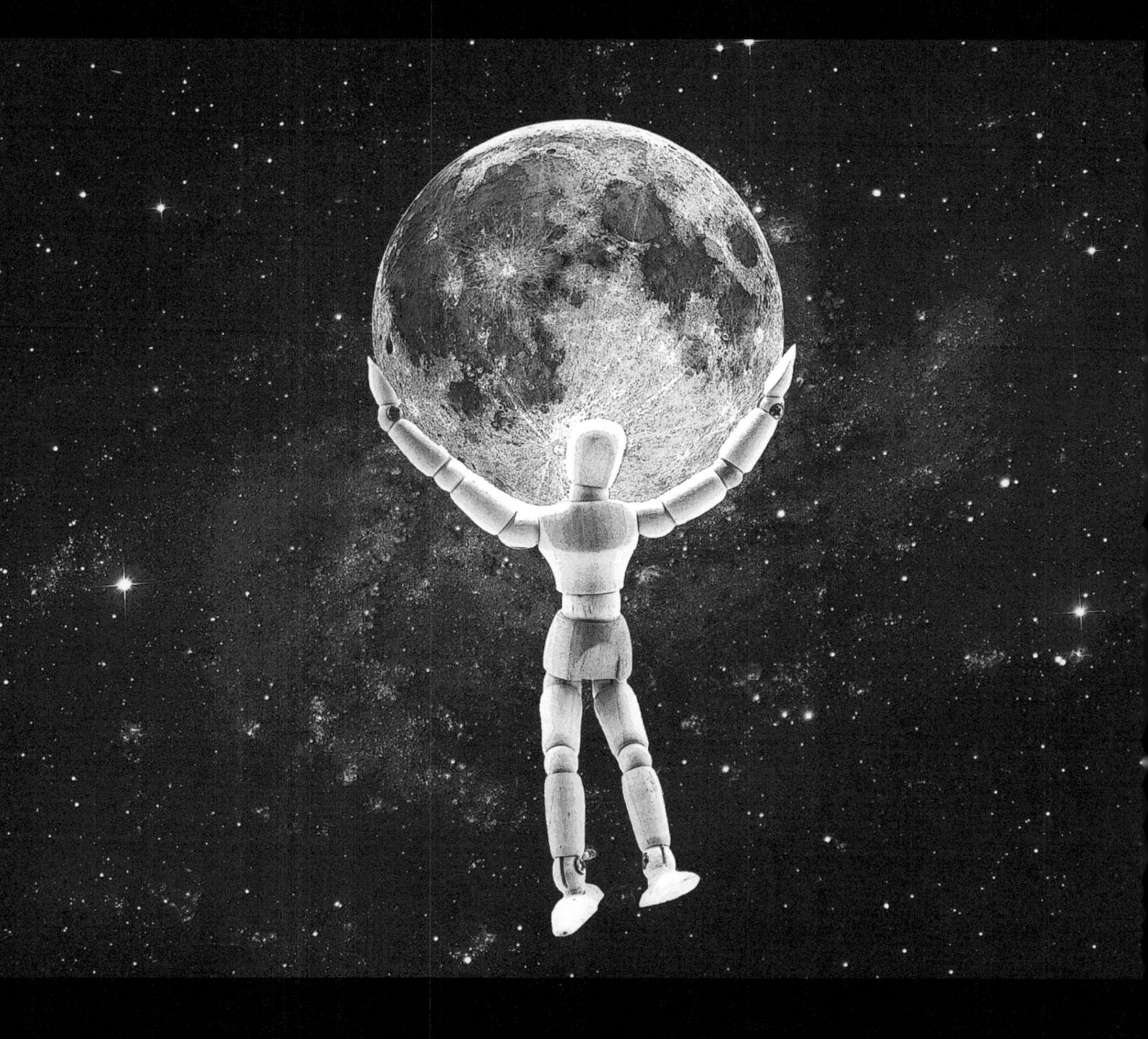

Before making any decision, Enkidu stopped at the moon. Earth's bright satellite, cold; yet floating so close to the warmth of Mother Earth, an opalescent pearl hanging in the dark velvet landscape of space. Initially confused by his observations, Enkidu suddenly realised that the people who lived on the blue planet did not understand how precious was the ball illuminating their nights, even though her memories were still reflected in their stories, poetry, music, life, in feelings of the 'lovers' moon', and even 'lunacy'...

What did they still know of Selene, the Moon Goddess? Did they know She had been spinning around the Earth for billions of years? That it is She, who brings heat from the planet's tropics to the poles, maintaining the cycle of life? Do some cultures still use the moon to calculate the passage of time? How much had the majority of humans forgotten or just never been taught? Enkidu mused on why Earthlings were now so distant from the natural world?

While observing Earth from the moon, Enkidu noticed the profound changes the world had suffered. Tall buildings, fast cars and planes; there were lights everywhere, the Earth was almost as brilliant as the moon herself. Questions! Enkidu needed answers to questions bigger than the known universe. Now, his original certainties that humans wouldn't dive into a world of shadows had faded, he moved into unknown territory, in a quest to find some glimmer of hope somewhere. How fragile had been Enkidu's expectation; sadness fell on his eyes.

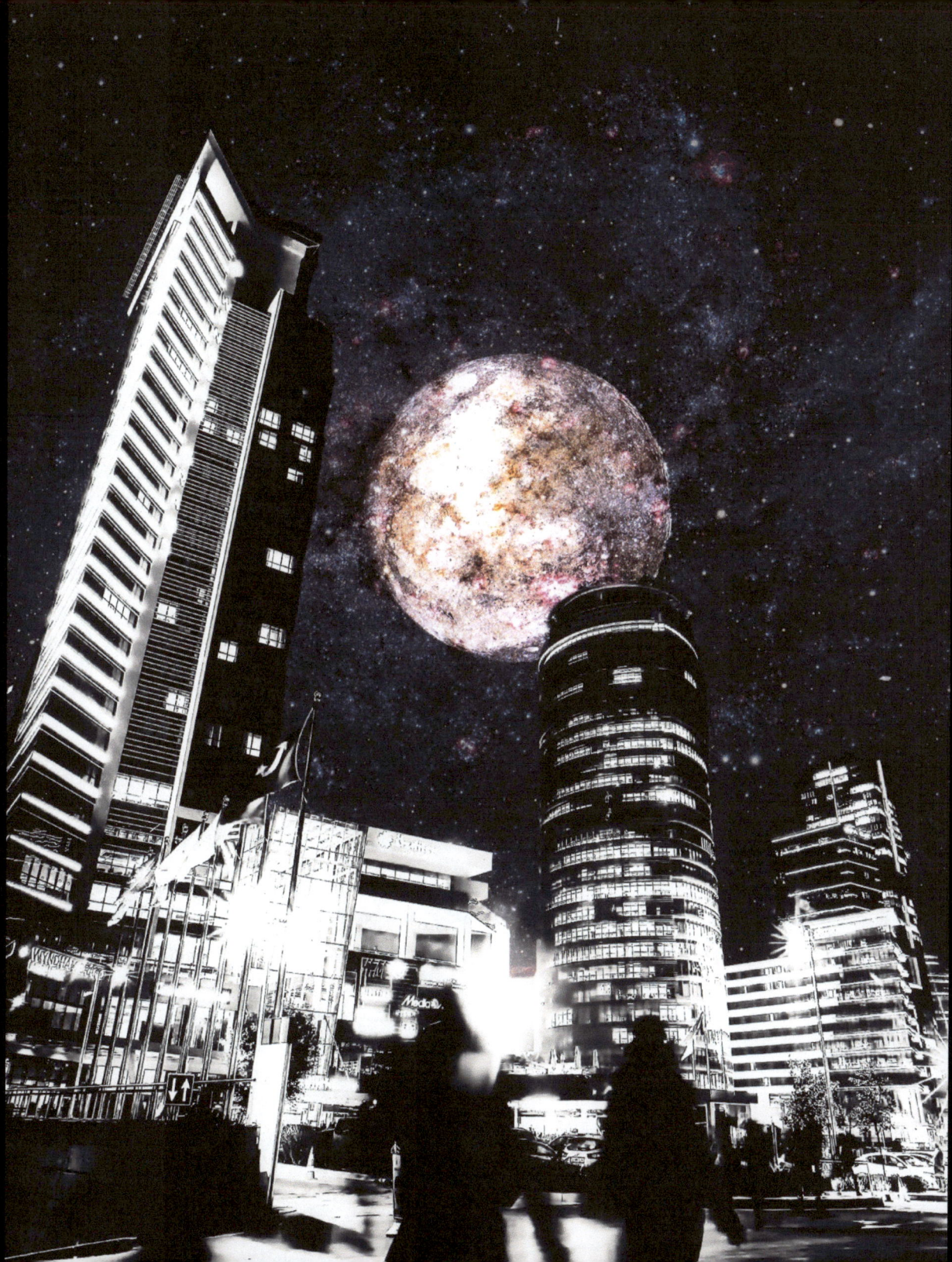

Taken by scepticism, Enkidu glimpsed a spark in the middle of the fog. "Who is that man? Is there hope beyond the deception?" Was that man a friend; a human friend? Might he be an ally? A soul able to help Enkidu to find the answers?

Now energised by hope, Enkidu left the moon and travelled to a big city. There, wandering amongst the layers of society, something caught his attention. Money. A simple word for such force that now ruled human life, relationships, feelings, hope and fears. Why had gold darkened the hearts of Earth's inhabitants? Why was this yellow metal more important than human lives?

In his anger, Enkidu cried out to the humans. "Fools, humankind is lost. Lost in nightmares, not in dreams. You're sleep-walking into an abyss without an end."

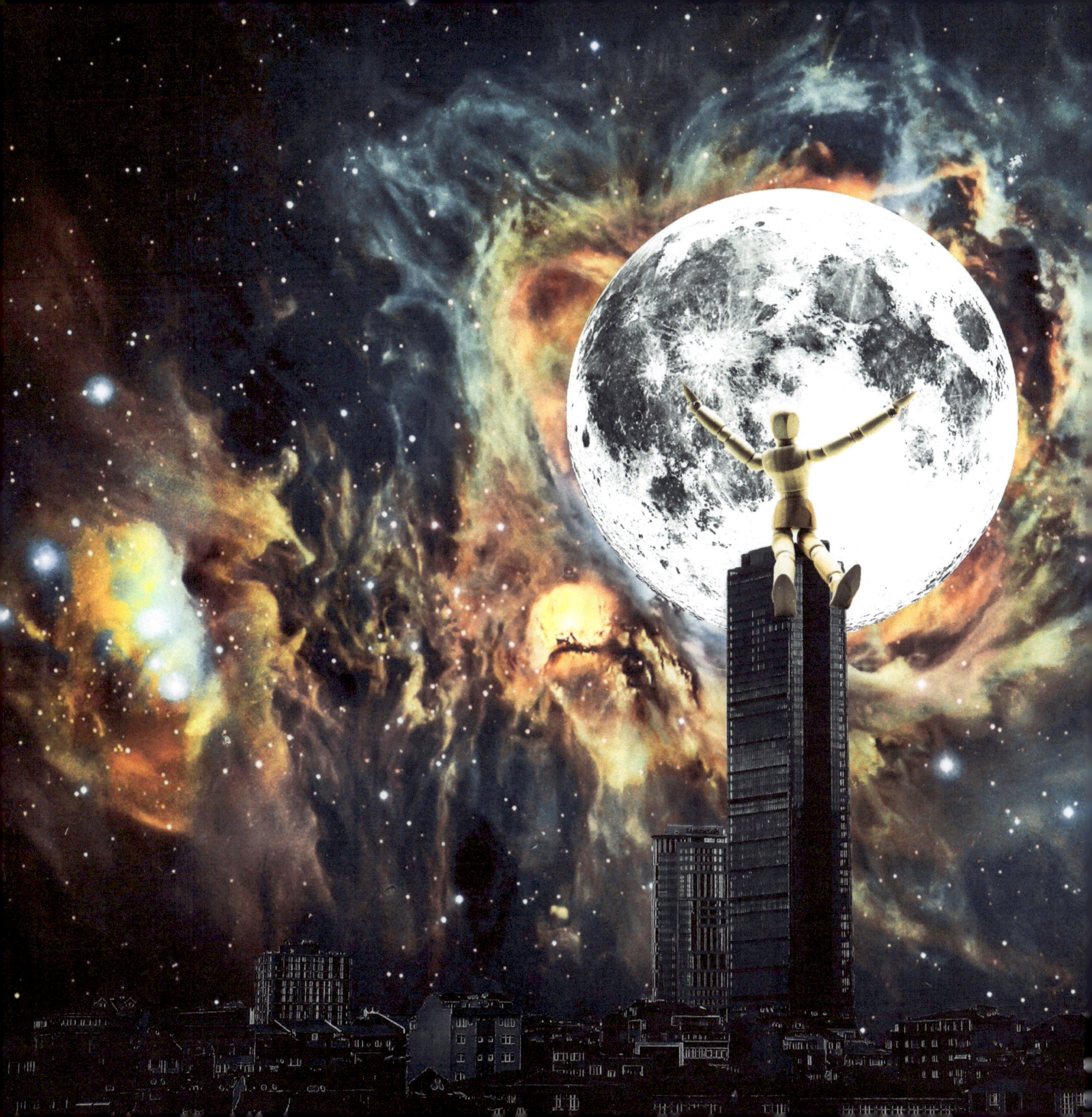

Tearing himself away, saddened by the scenes; the laments; the mad bright eyes lost, ever-trying to achieve more power, he now sought a place where he could ponder the future, a place where he could breathe the power of the past. Enkidu found the perfect location in an ancient city in one of the highest places in Anatolia, with a theatre facing the mountains, surrounded by echoes of the past, and the silence of the present. "Why?" His voice flew on the winds. "Why do they need always to conquer the top?" They always try to build the biggest, the tallest, the most expensive... The theatre was a memory, a reminder that human greed had increased from the past to present.

"History. Through studying history, you can understand better who you are, and why you are here." Enkidu knew about the old civilisations, and now he was learning about the new.

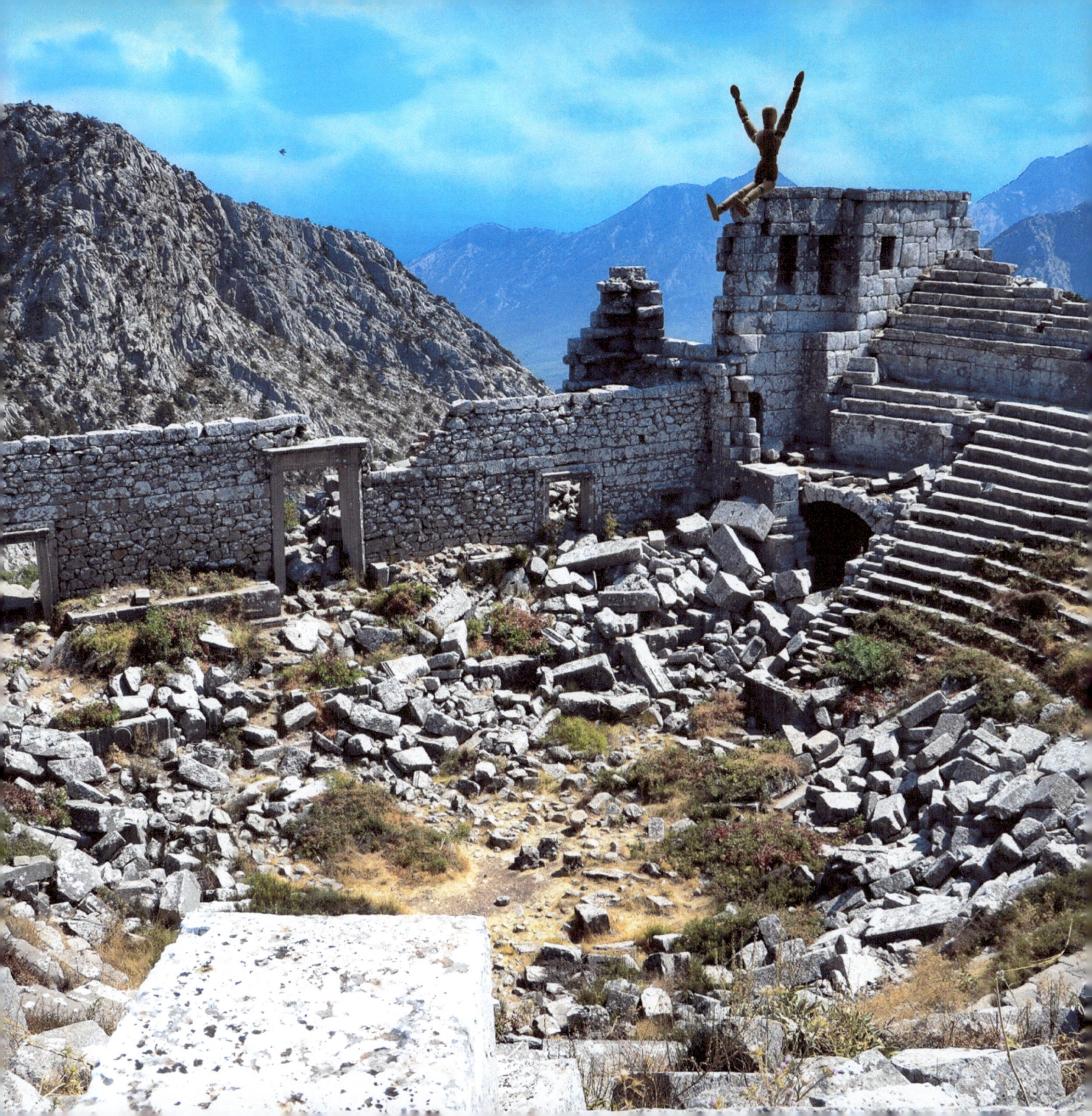

Exhausted, his strength had been sapped by all he had learned, Enkidu slept. Alone. In his sleep, a dream came wrapped in clouds. "Was it the Earth?" He was dreaming about a harmonious planet, where green and blue were the predominant colours. A place for humans to evolve, to rediscover happiness and fairness; returning to the simplicities of the past.

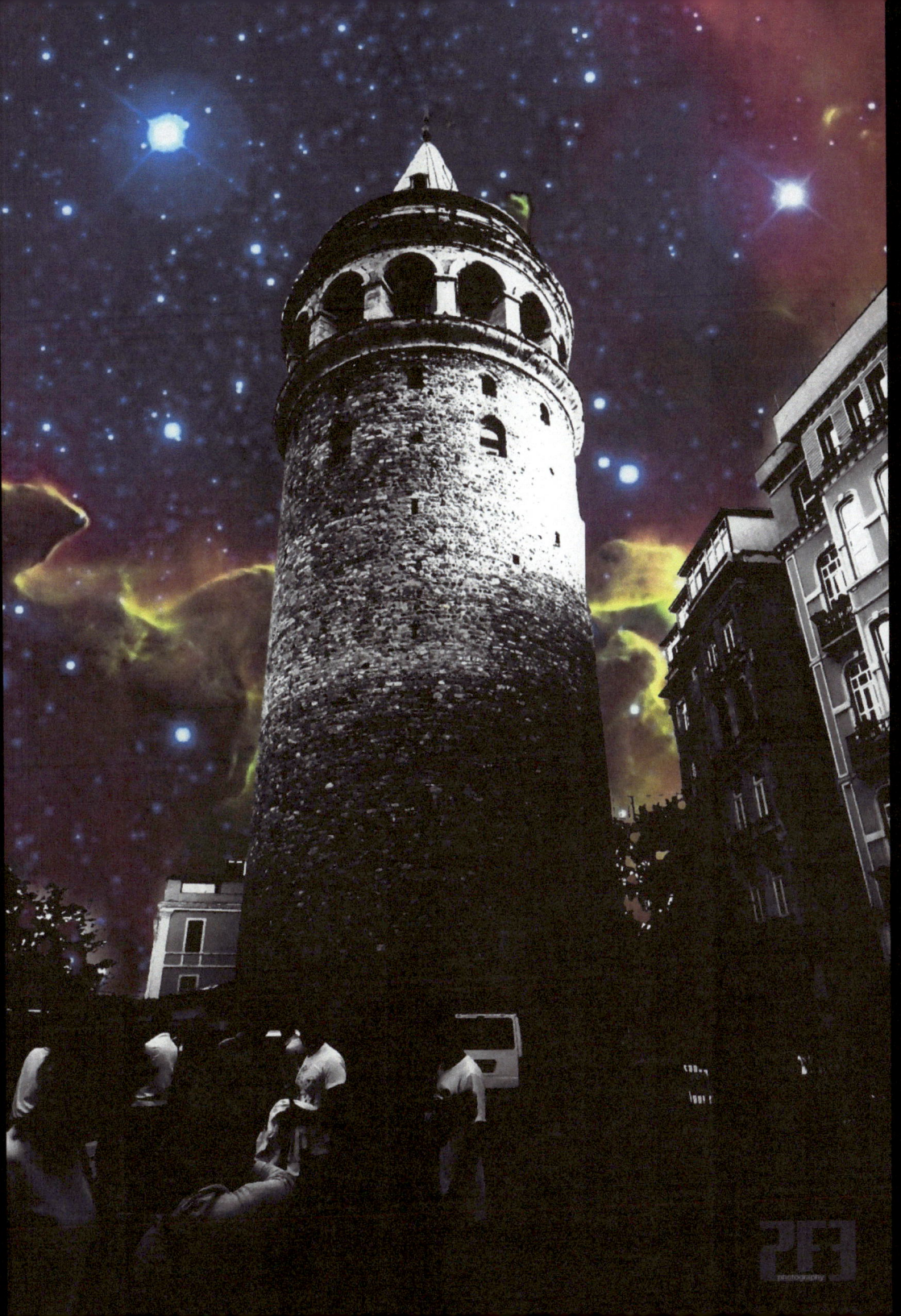

The sun rose; its light awakening part of the planet. "Why had humans changed?" That was a question with no answer. "Why did the people who had followed the moon, and the stars, always with their eyes on the skies, lose sight forever of the nebulae, the galaxies, the cosmos, once they had learned to reach towards those very skies with their buildings? Why was trade now the only master, and why was curiosity and wonderment at nature seen almost like a sin? No more dignity, no more searching for wisdom, no more..."

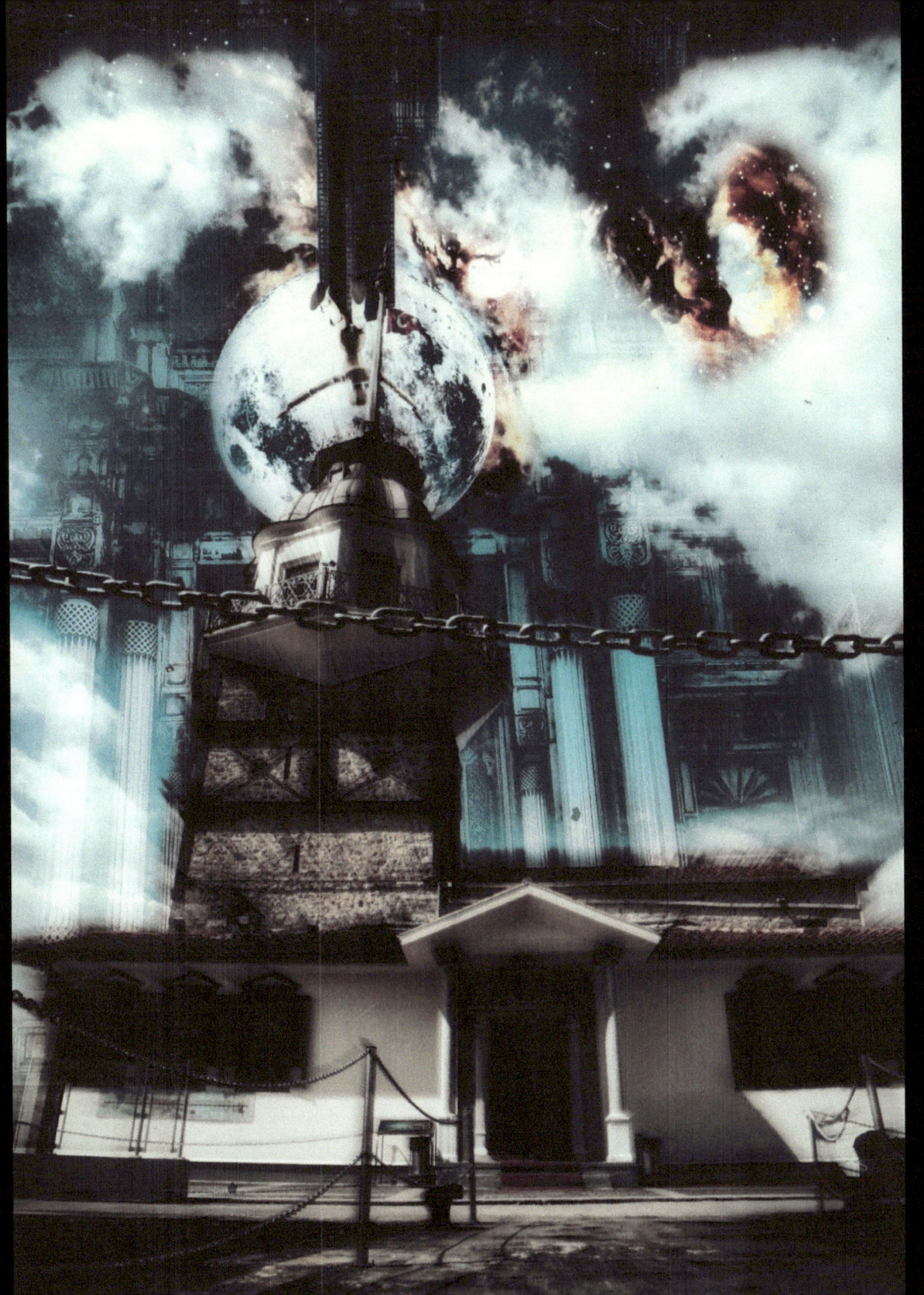

Enkidu left the moon; returning to Earth, he wanted to meet his new human friend – a man of questions and doubts, strengths and weaknesses, concerned about his planet and the lives of those living on it. Together they looked far and wide, hoping to find that little spark of dignity in a leader's brain; the dignity to negotiate, to hold-back, to stop wars. It was a vain hope. Peace was a desirable state but not a task in which the people were engaged.

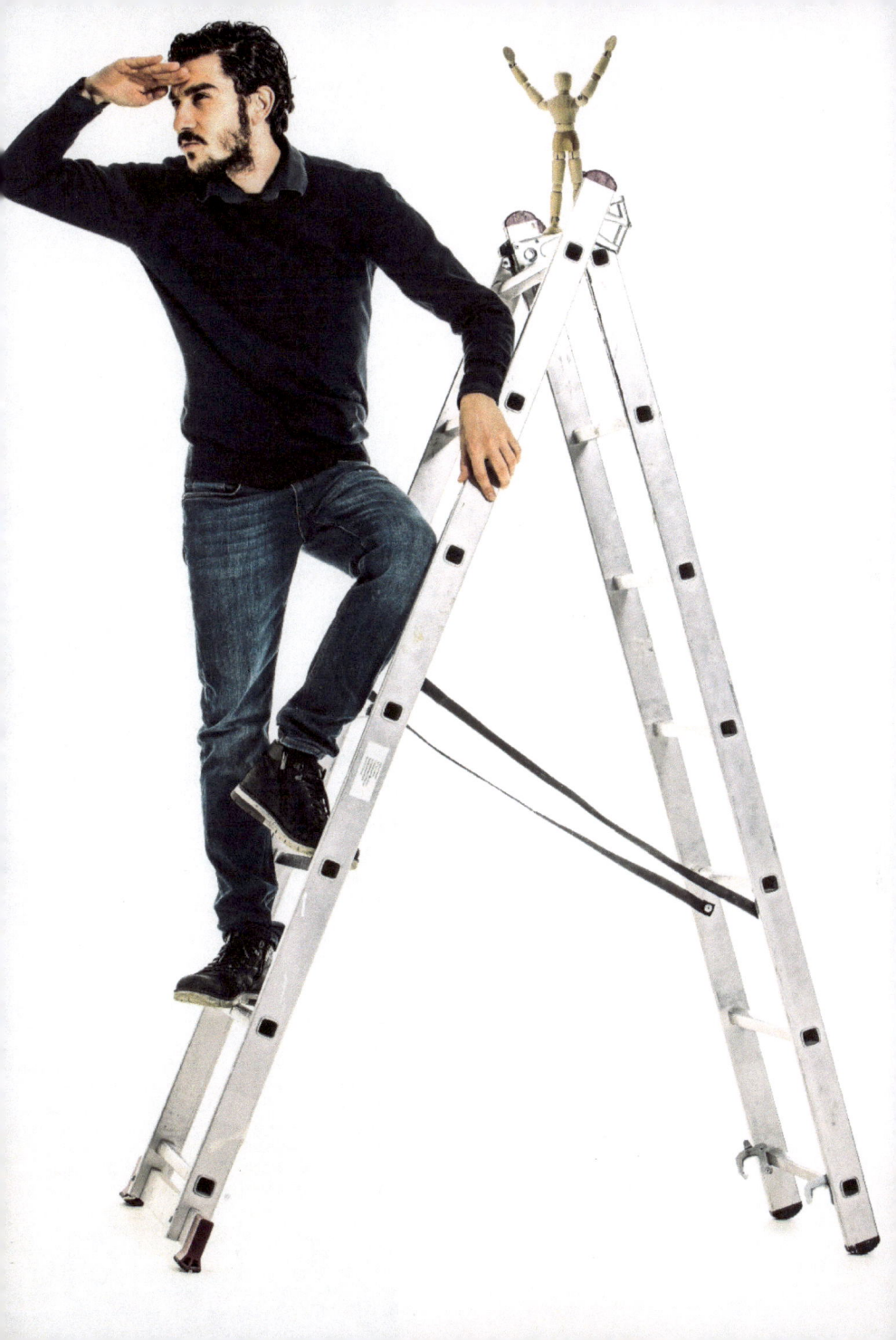

Back in the safety of Selene's silver bosom, Enkidu reflected on the questions his new friend had asked. Why did humankind want to reach a distant red planet? Why the obsession with so far, a place when the moon was near, waiting? Was it about money? Or were they foreseeing the unavoidable destruction the Earth would suffer and planning to run away? What was the evil behind this hope?

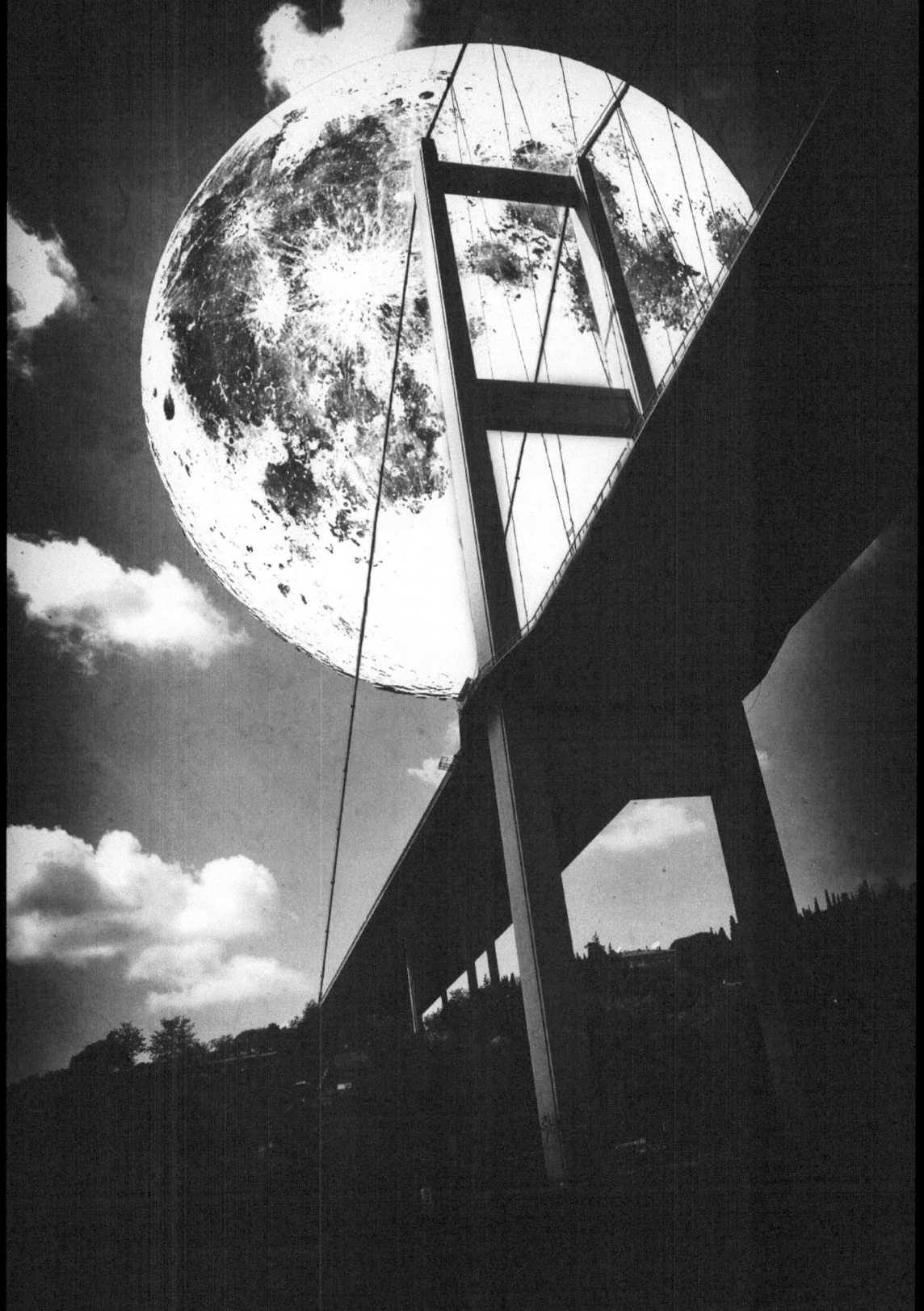

Closing his eyes, Enkidu observed the humans, following the evil within them...

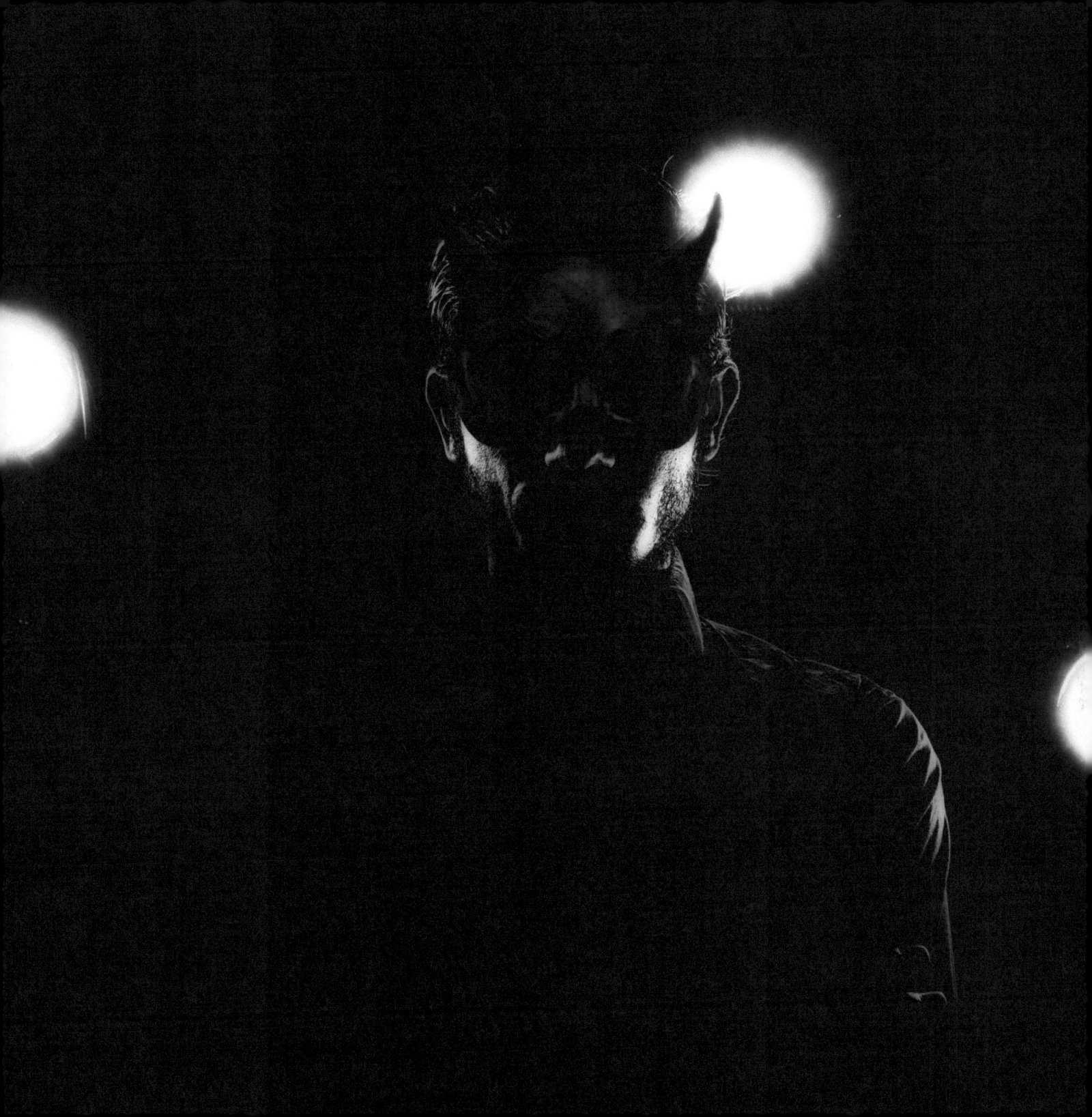

Knowledge is the fountain from where wisdom and reason are fed. Knowledge can be found in many places, available for any who desire to drink its words. Enkidu's best friend read; questioning every idea he had previously accepted. The books made him humble. They also helped him to understand that simply reading is not the only facet; he realised that one needs to reconsider and really look to understand the inner meaning of what you read. That, how you read, is as important as what you read. Enkidu's friend became thoughtful.

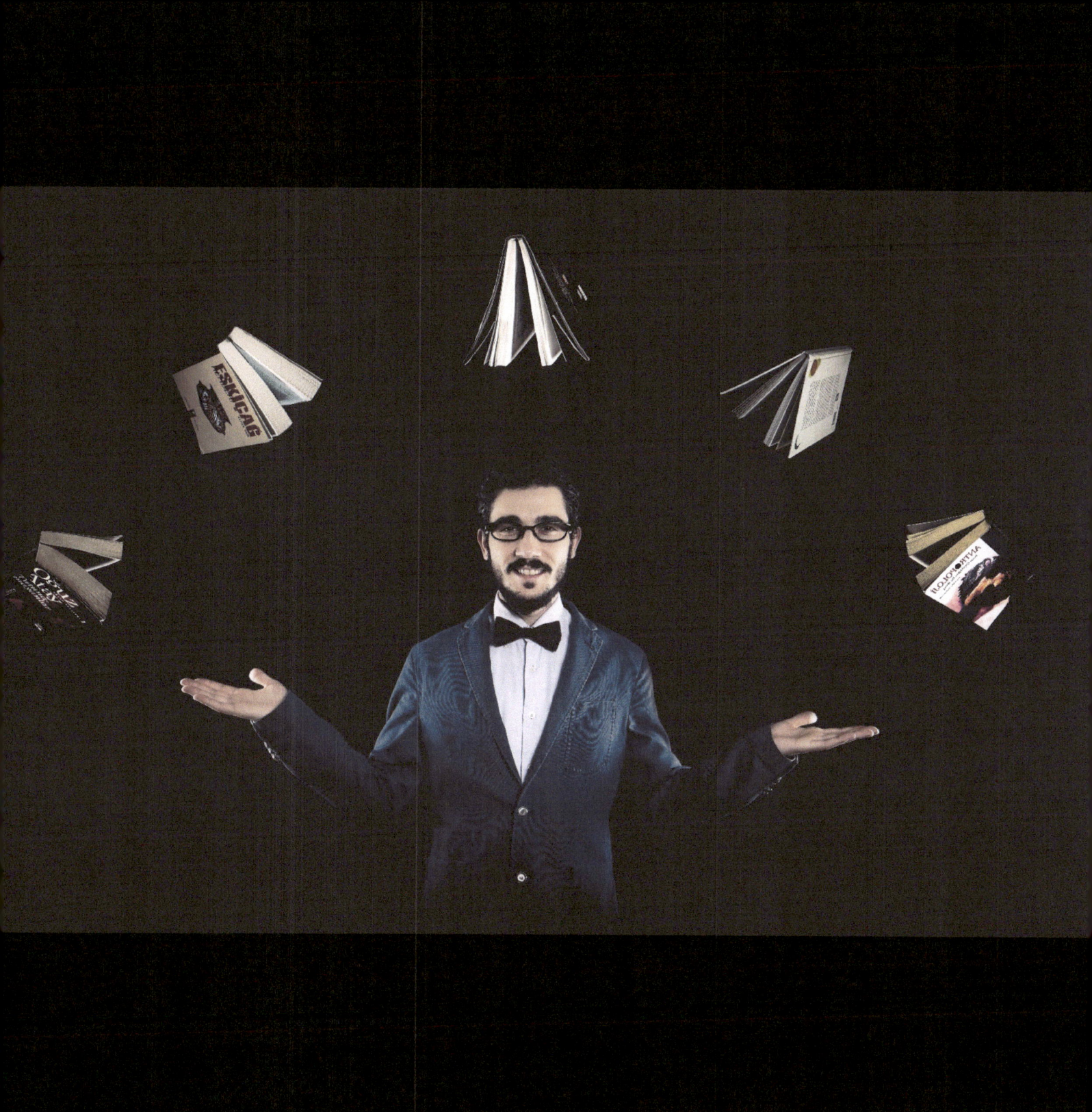

Enkidu needed to see more. Flying past the buildings the men had built for themselves, he happened upon an ancient tower in the middle of the Bosporus Strait; a tower with a salutatory tale to tell – the story of a Byzantine emperor's daughter. She was sent to the tower to protect her from the enemies of the Emperor, but she felt isolated, imprisoned. In the end, it was all to no avail; the girl was bitten by a snake, placed by those enemies in a basket of fruit her father bought her as a birthday gift. Are all humans, too, trapped in their own ivory towers, eventually to be poisoned by the serpents that they had created? Who would end this mess in which they had entangled themselves?

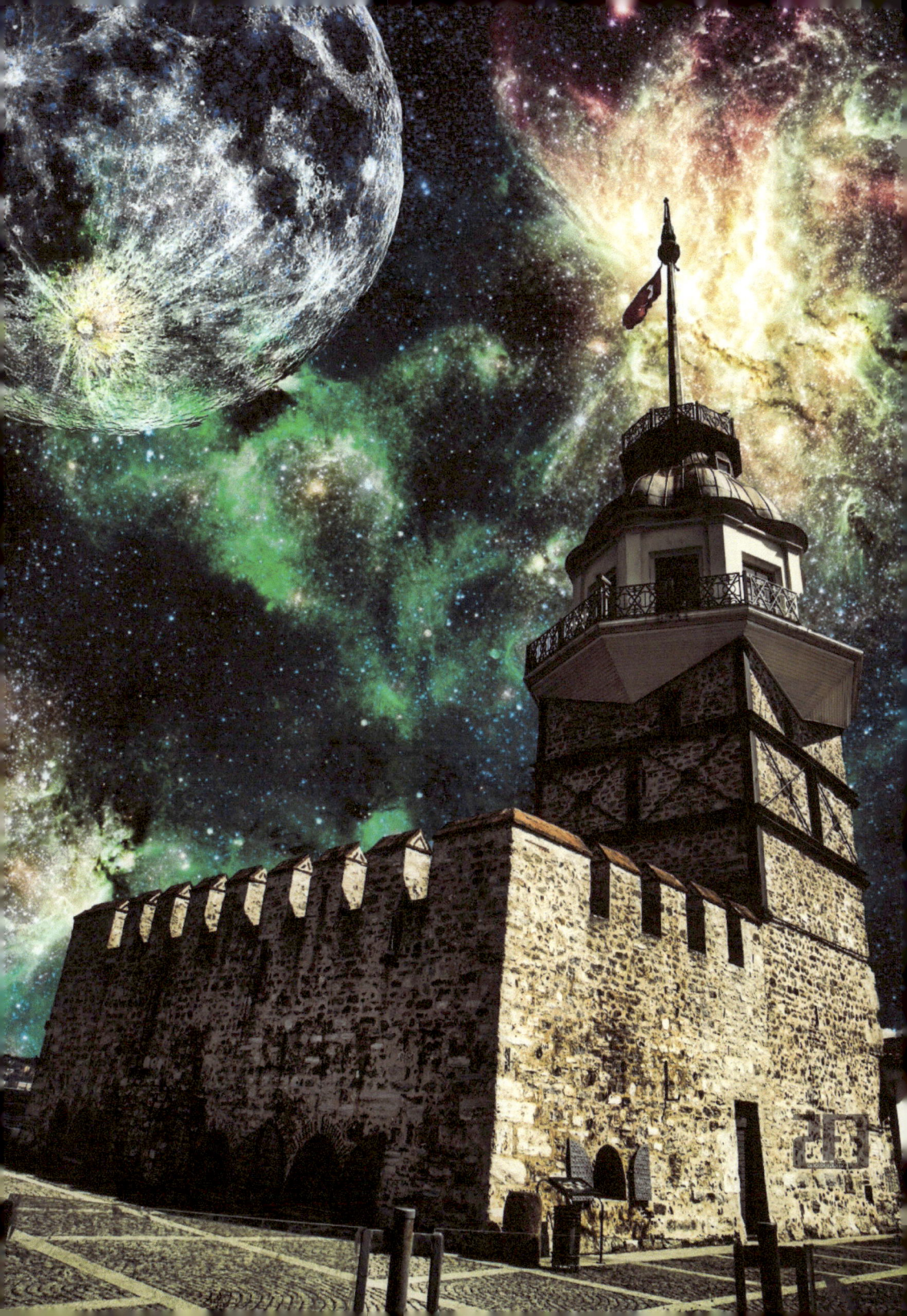

"Routine, the towers are temples to routine. Has such routine broken the Earth people? Every day they wake up early, go to work, check their emails, replying to them as soon as possible – each life on fast-track to a sad, embittered death. Have they sacrificed all the beautiful moments of life because of the 'need' to earn and to save for the future? Just what future will that be? Why is feeding their egos more important than being with their friends and family? If such people don't change there will never be a peaceful and comfortable future for humans... "

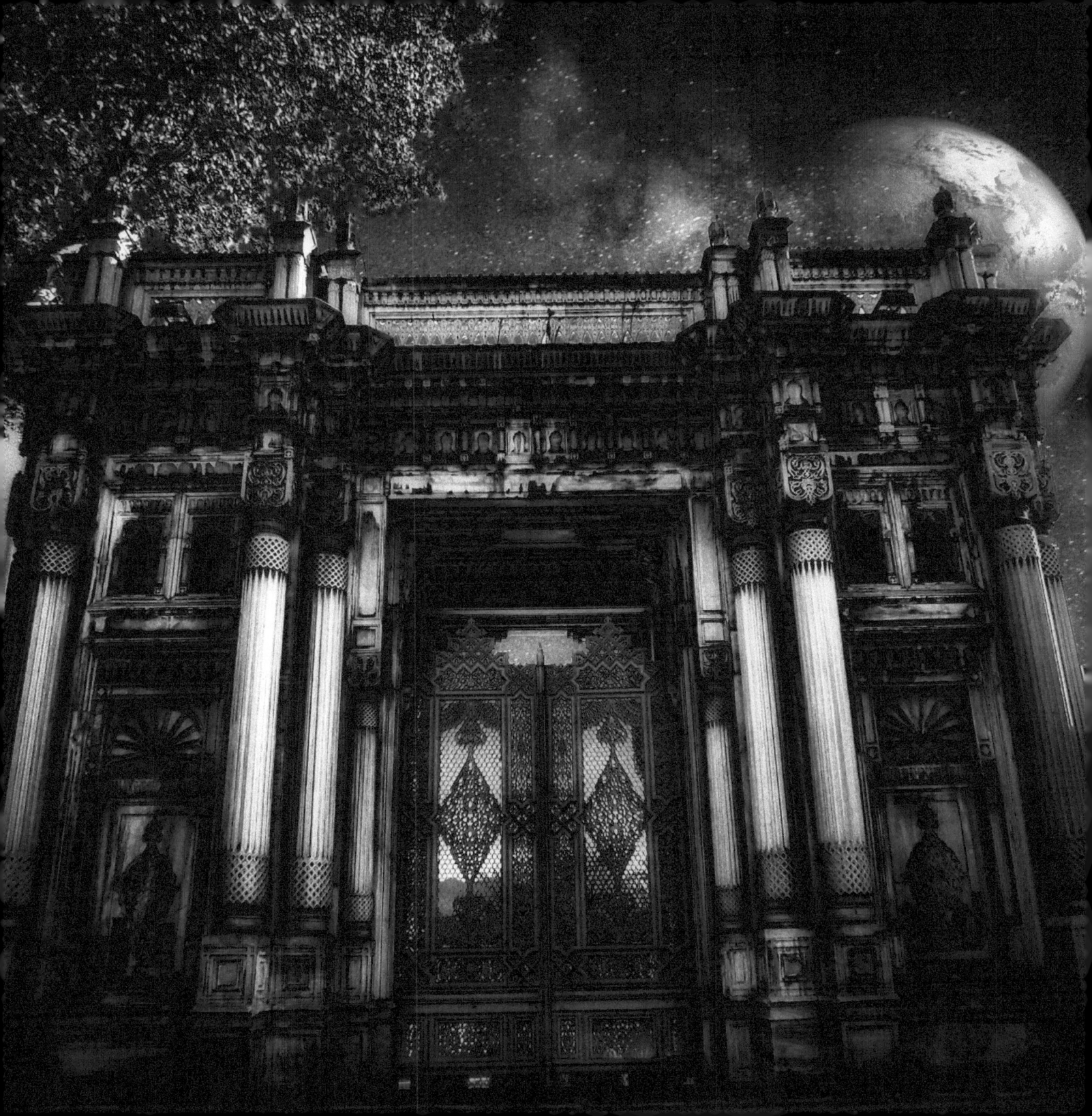

Enkidu's heart was heavy. His mind wrenched by the anger, fury, hunger, and violence he found between brothers, sisters; between humans. "Guns! Guns killing; blood flowing; tattooing the Earth - a permanent red stain on the conscience of man…"

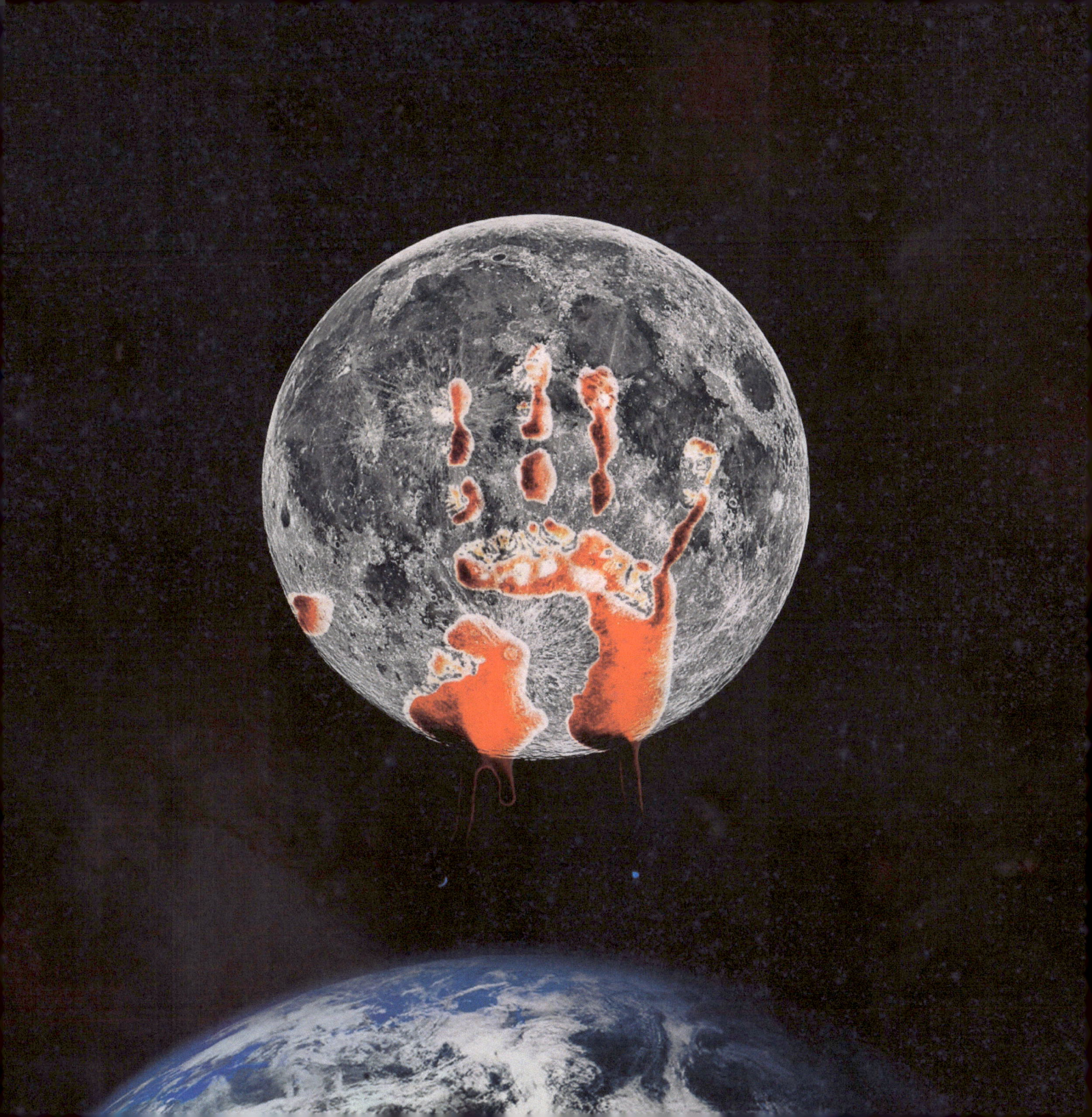

He retraced his path back to the moon; a place to reflect. She would still be here when most humans were gone – gone because their 'civilisation' had died, gone because they had killed each other – but the moon will prevail, a silent witness to the self-destruction of humankind, she will be here until the sun itself dies and the solar system is absorbed and its parts transformed, reborn in a new tomorrow, a new beginning...with new hopes...

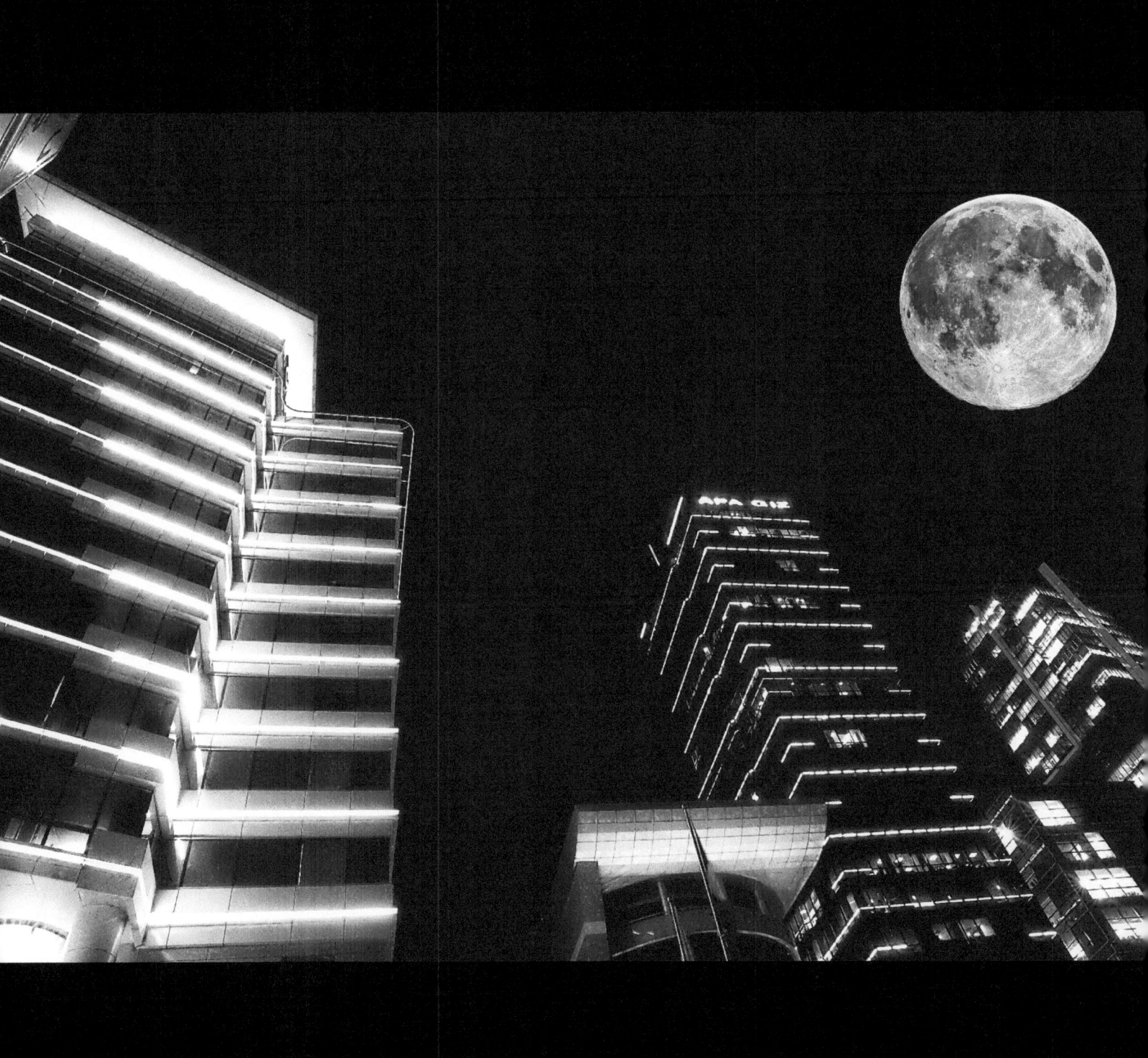

"What was humankind? What meaning have they given to their species? It won't be gold that will elevate them to the skies, nor war that will give them peace. How can I make them understand how important each individual is yet, at same time, how insignificant the whole population is in the universe?" That contradiction is the lesson Enkidu wants to teach them.

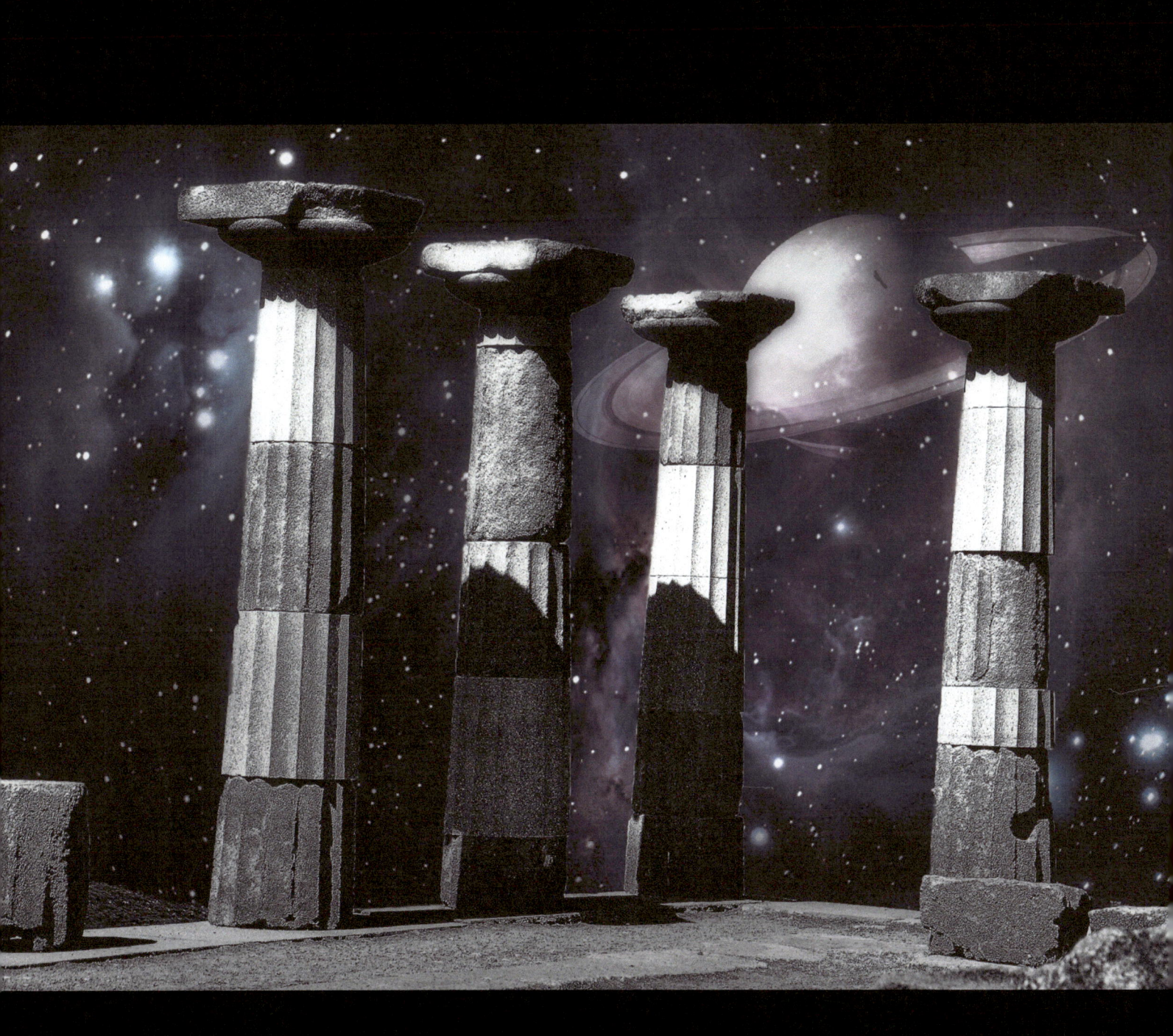

Eyes closed, Enkidu sees the future. The Earth in flames, the only home humankind had; destroyed. "Is that what you want? Did you plan that?" His questions shouted into the silence of space. Then he sees the emptiness, the leftovers, when humans are no longer the lords, when less-demanding life reclaims the planet.

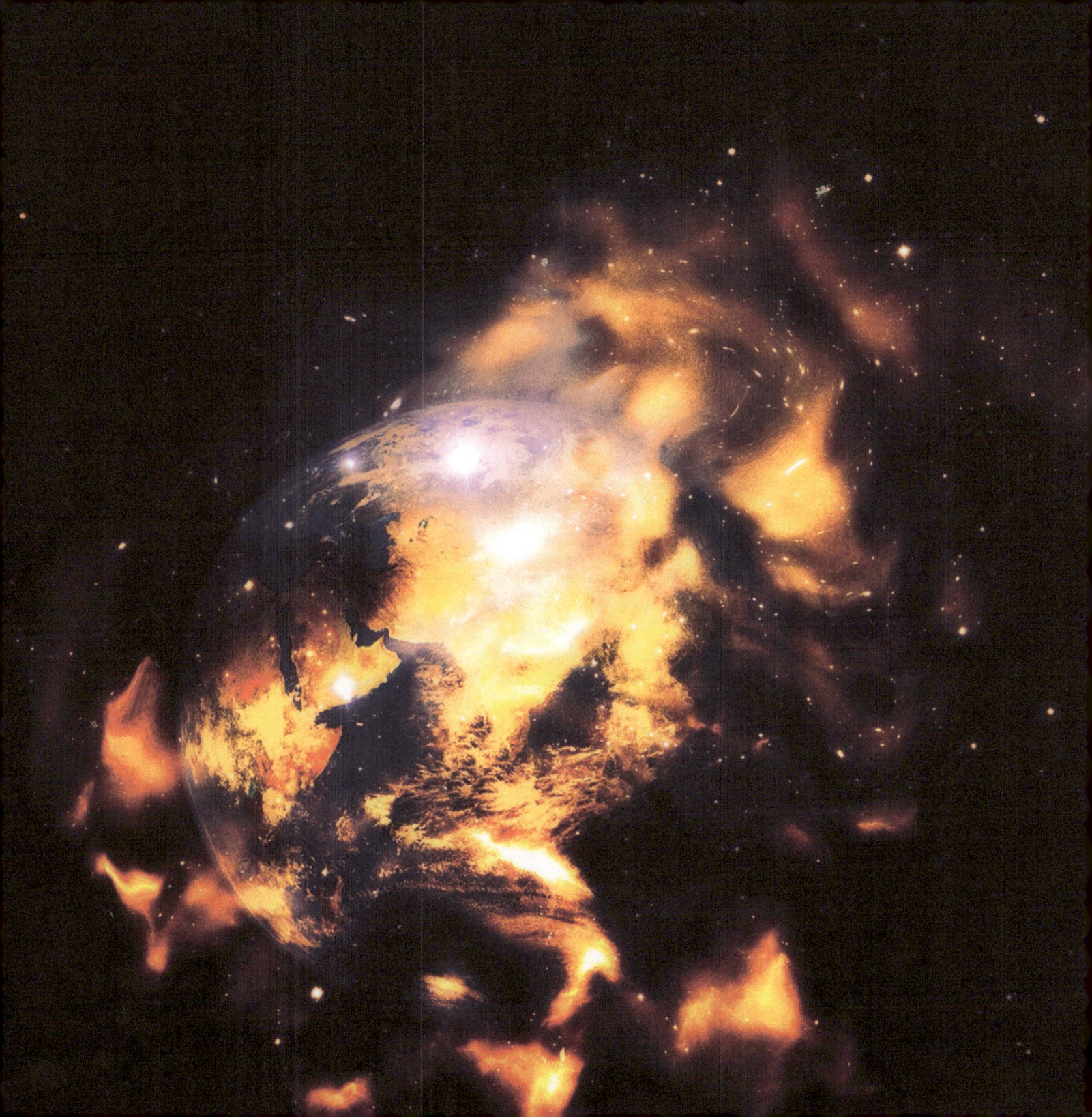

The planet is dry, all the trees are gone. Protecting the forest was a duty man could not fulfil. Enkidu cried, was there still time? Time to turn back and rebuild the natural world?

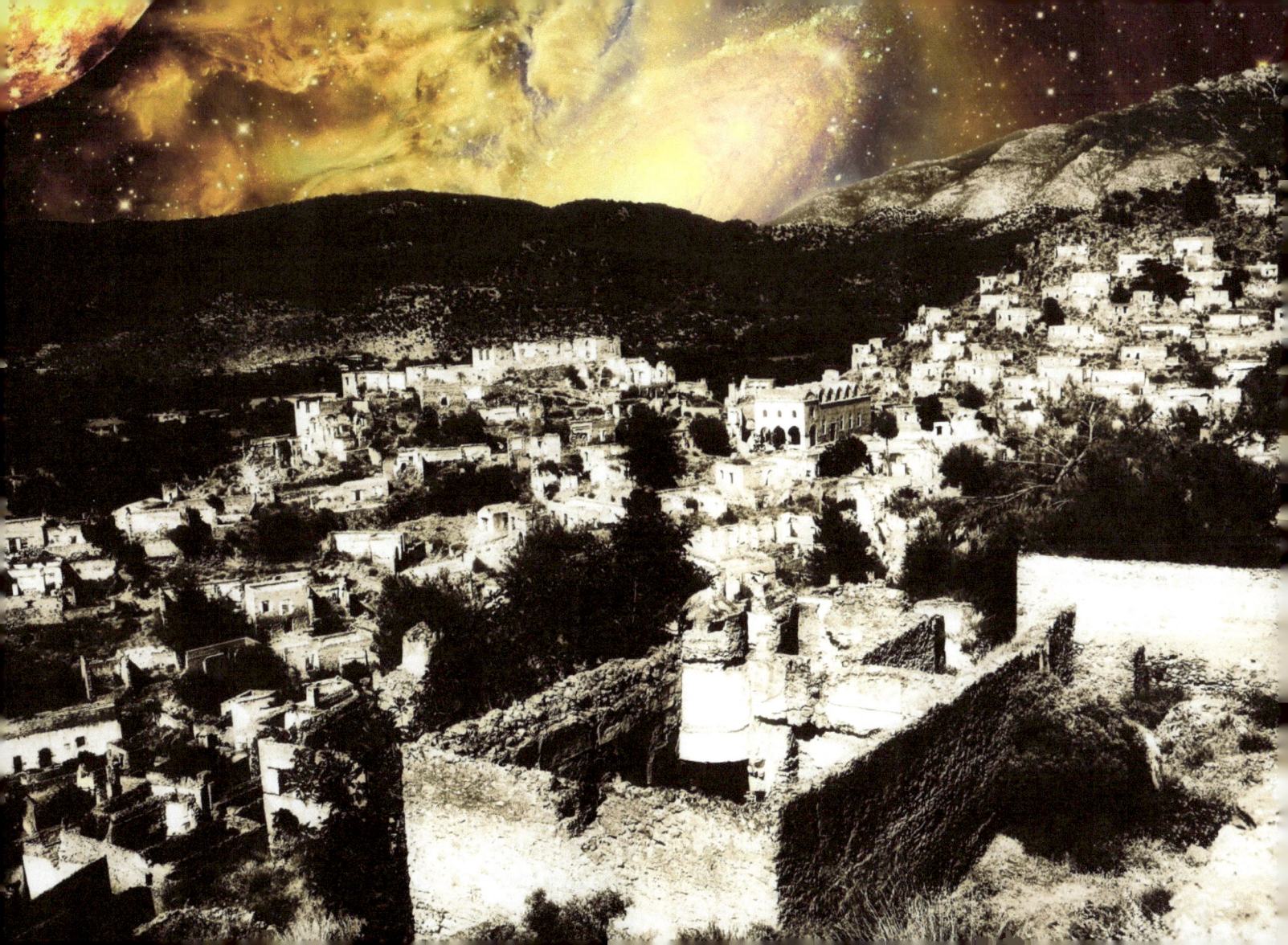

And then he dreamed in h

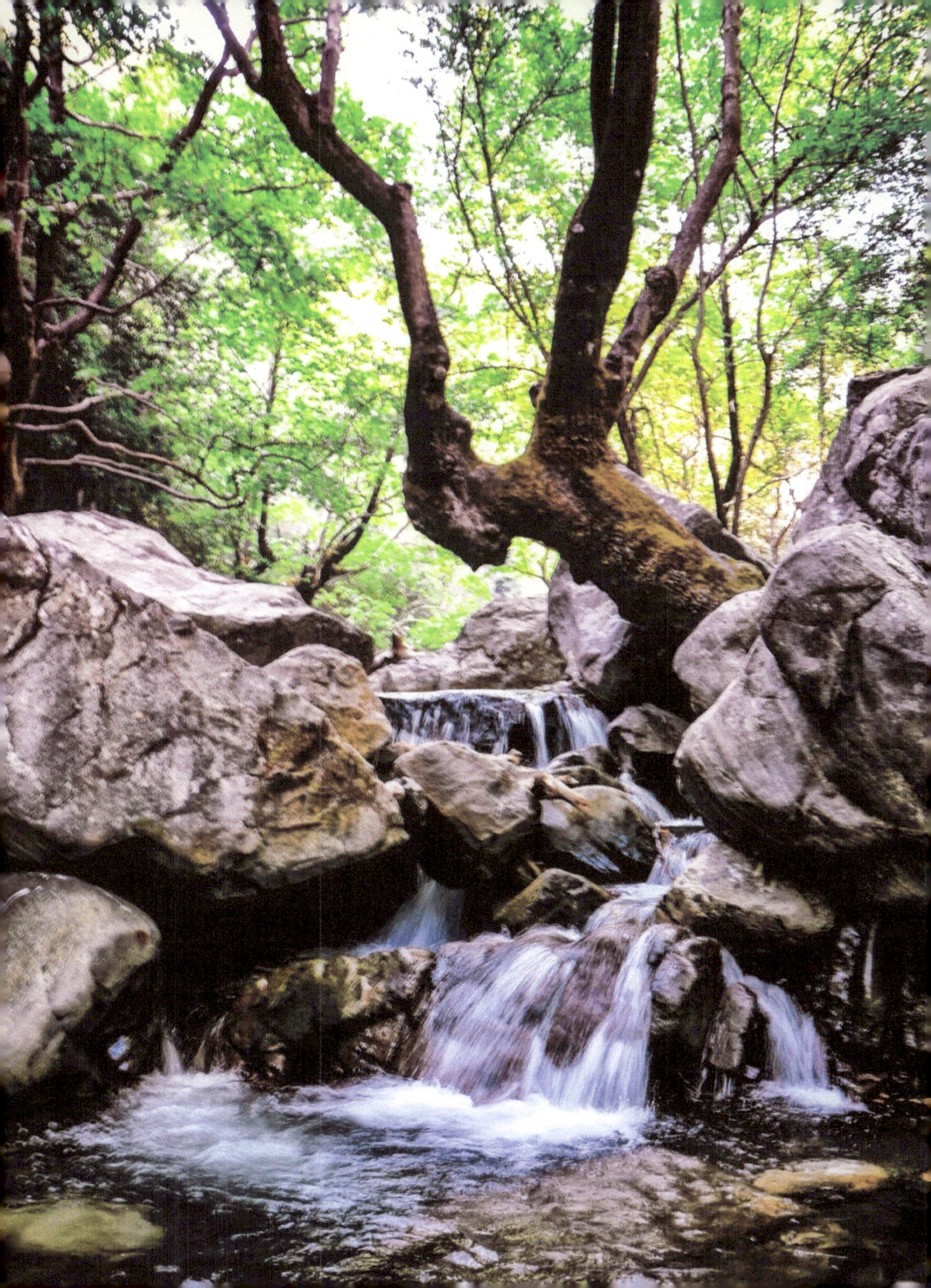

Some of them were trying to clean the Earth. Taking energy from the sun, not from oil or wood, but by erecting metal towers to capture the natural strength of the wind. Is there space for hope then? Yes, there is. But don't wait for a miracle; the ice caps are melting away. The cities burning or freezing; there are changes everywhere, but not good changes.

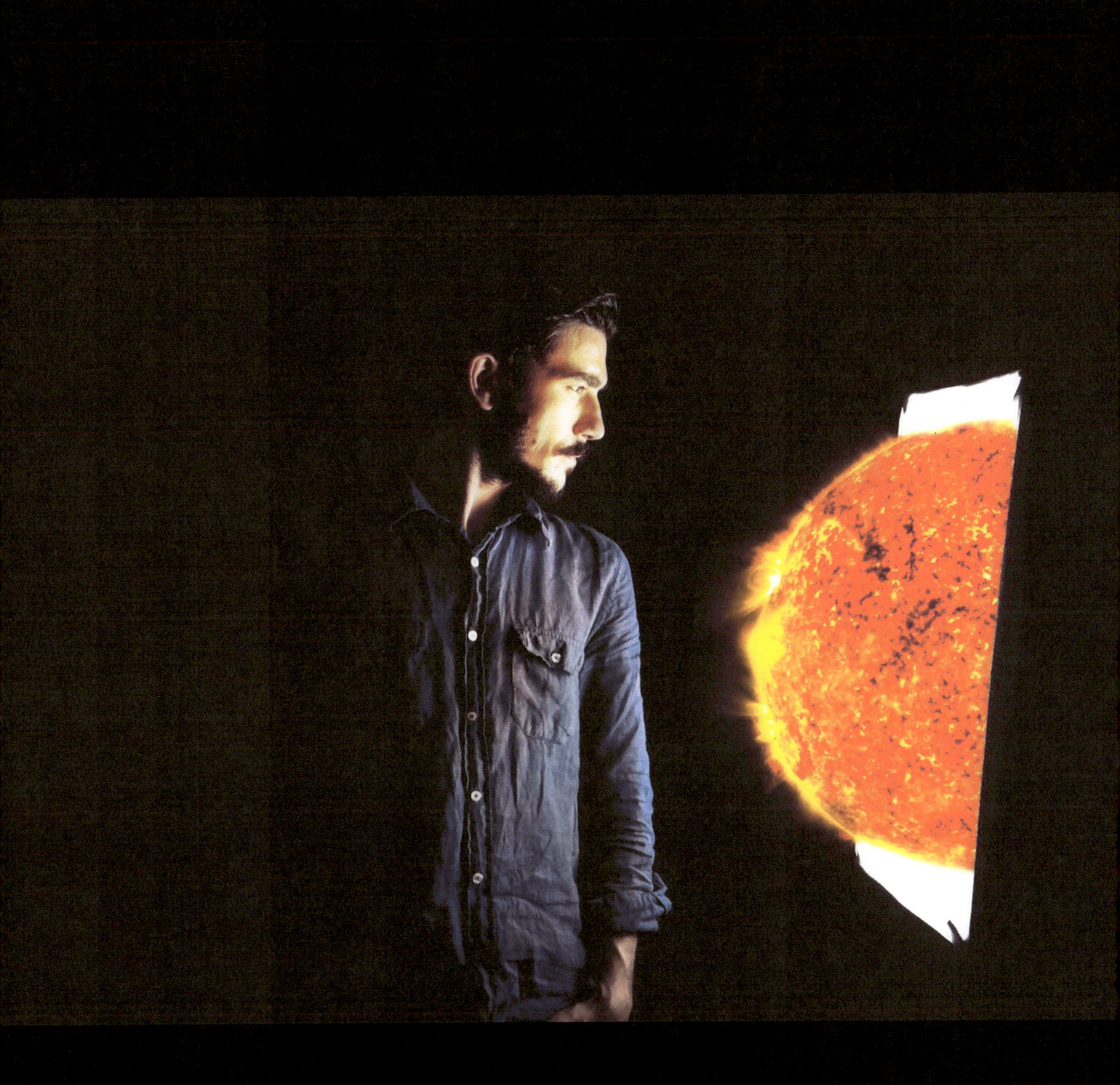

The skyscrapers are the masters of the landscape in the modern-ancient city, seagulls are circling them searching for food, and maybe a healthier morning... but, on their flights through the inner city, they find only fumes; unhealthy leftovers; pain.

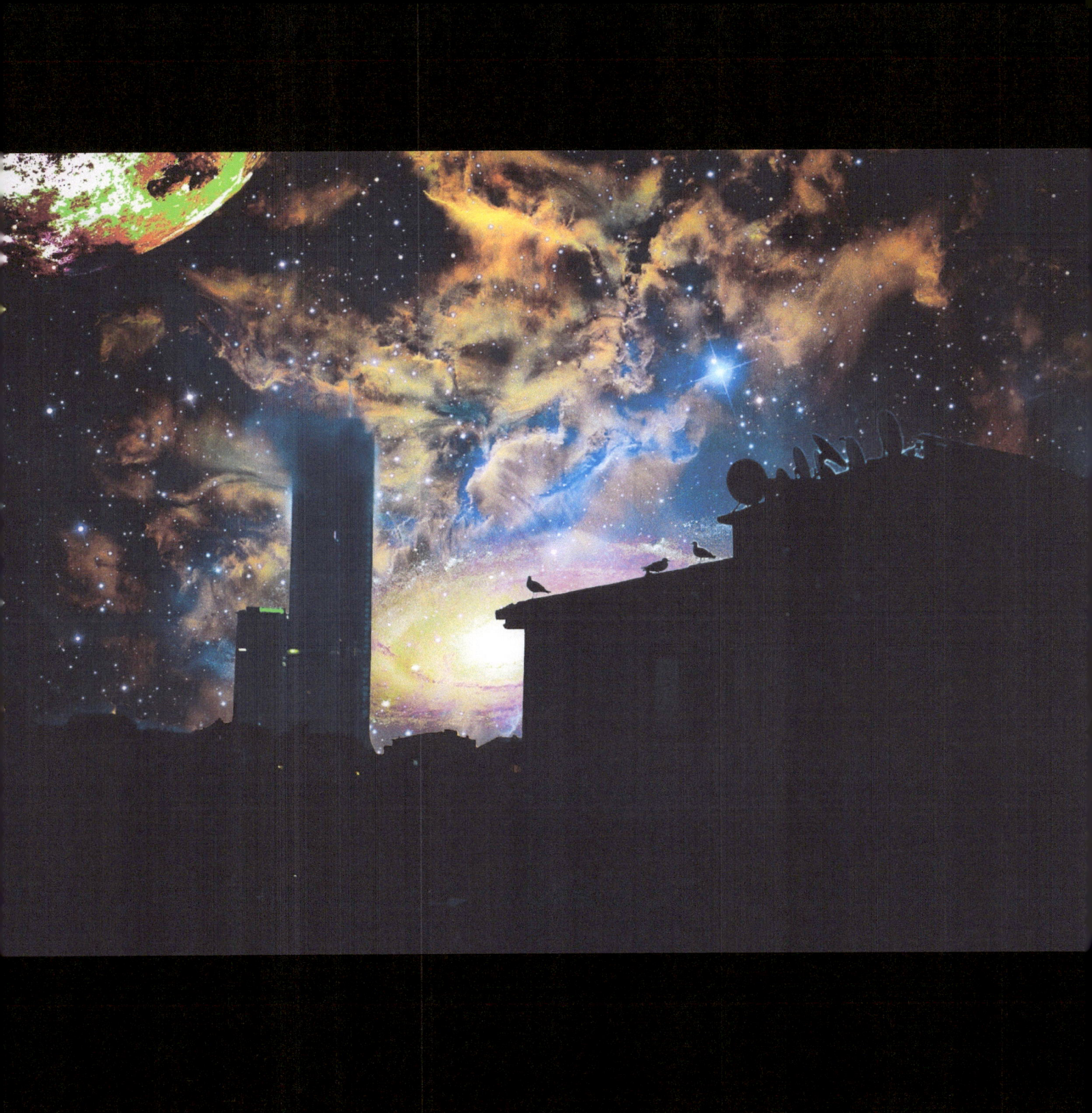

Enkidu finally decided. He would keep Earth in a jar, far from those who do not understand how precious she is; far from anything harmful to mankind's home. He hopes that the future will bring some dignity to the next generation, or maybe he will find another civilisation somewhere in the cosmos that understands, and can bring cheer and hope to their place between the stars.

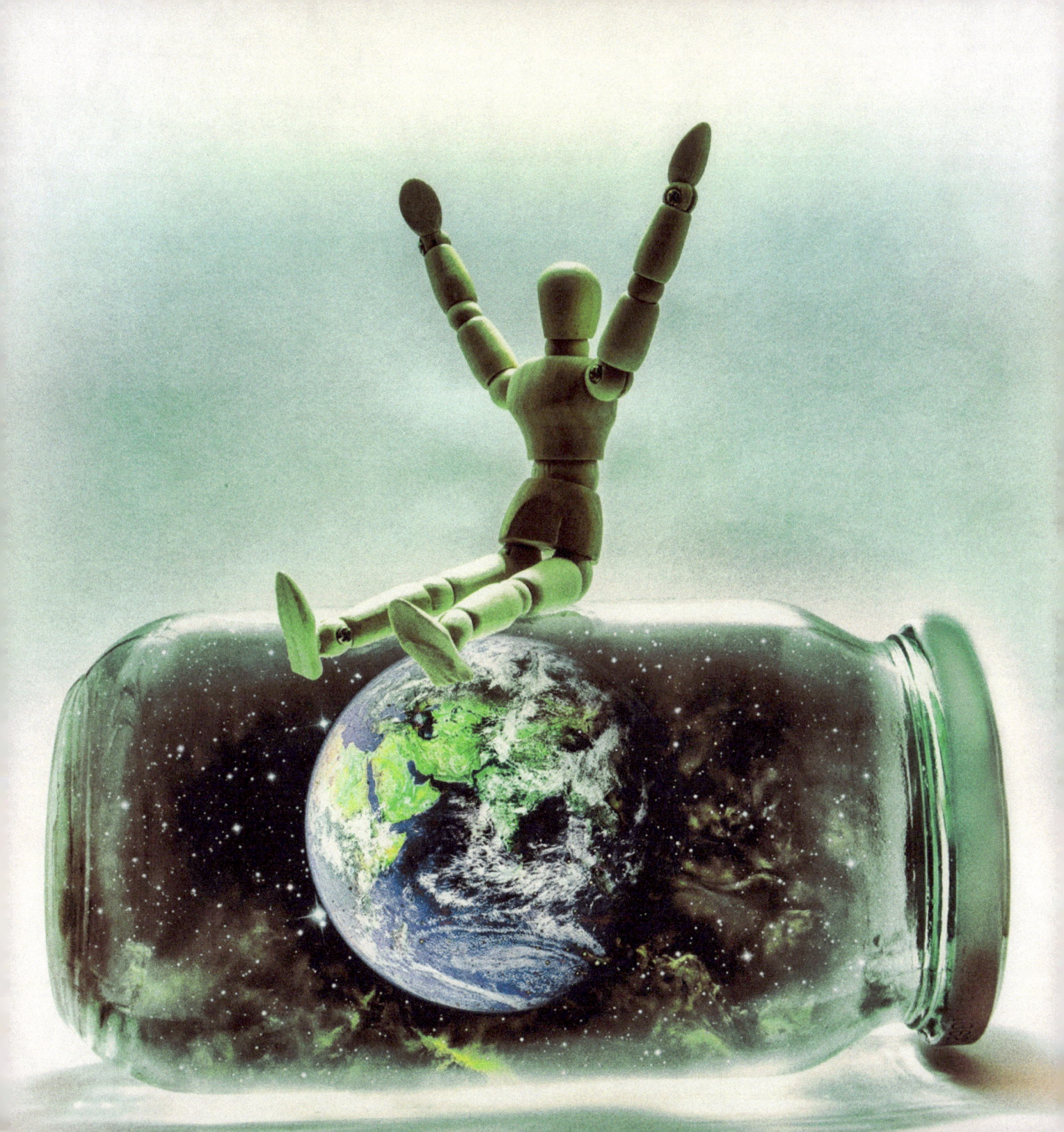

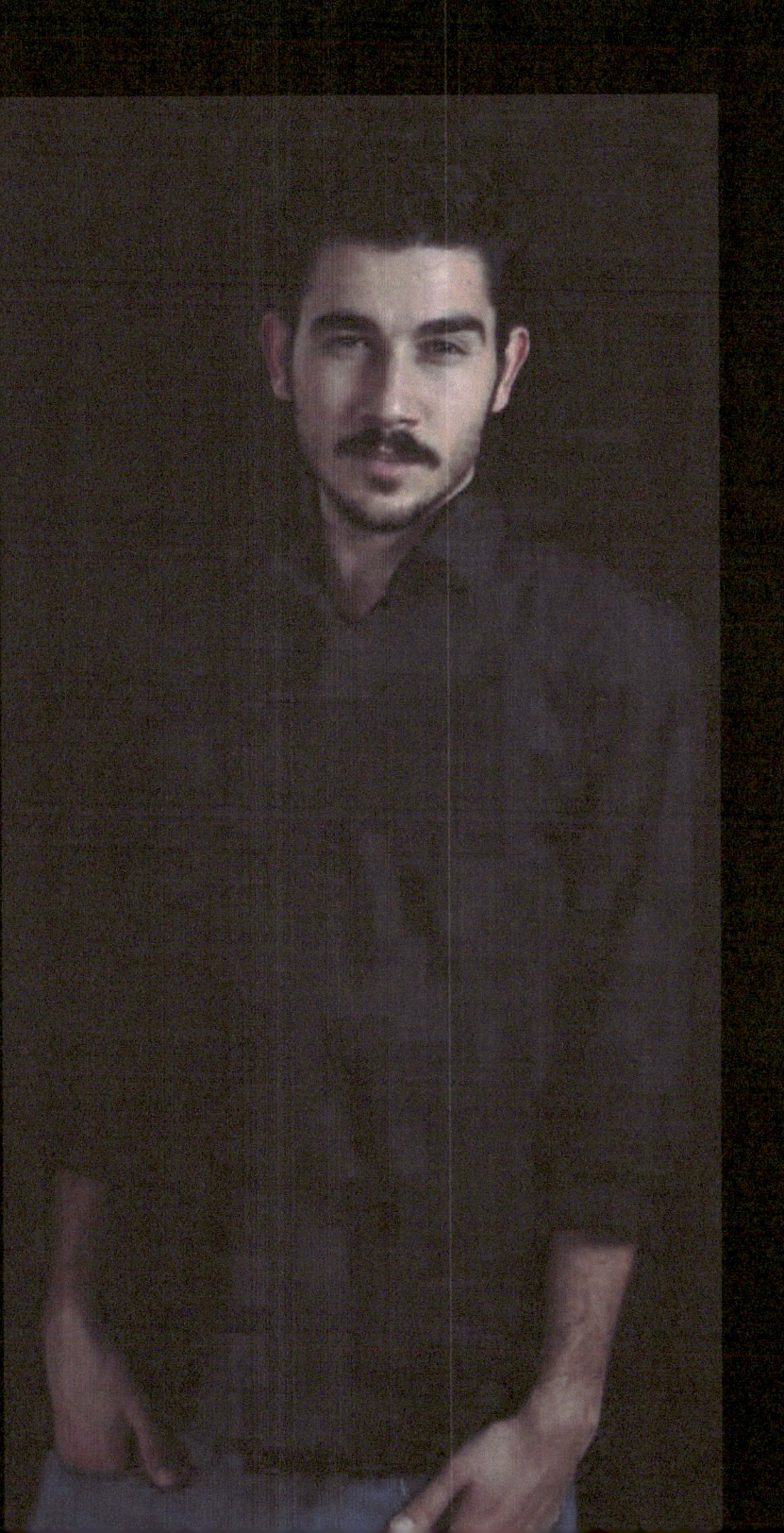

BEHIND THE LENS

I was born in Adana, Turkey on November 4th, 1984

I graduated on Tourist Guidance at *Kocaeli* University.
I began working as a Tour Guide, I moved to İstanbul., where I still live. My job was field that gave me a sense of seeing the world around in a different perspective, or was my country, full of natural and ancestral beauties. And I met lots of photographers I saw beautiful shots. In that time, the camera they were holding looked to me spaceship. Later on, I wanted to grab one of the them.

Today unlike other fields, Photography requires better and newer styles all the time. It updates itself, and it is not cliché, that's why I am in love with it.

Enkidu

Project creator: Seyfeddin E Erisen
Photography: Seyfeddin E Erisen
Design: Heleny Campoy
Story: Heleny C ampoy
Editor/Proffreading: A. Haynes

www.ingramcontent.com/pod-product-compliance
Lightning Source LLC
Chambersburg PA
CBHW051053180526
45172CB00002B/621